Creative Colored Pencil
LANDSCAPES

Vera Curnow

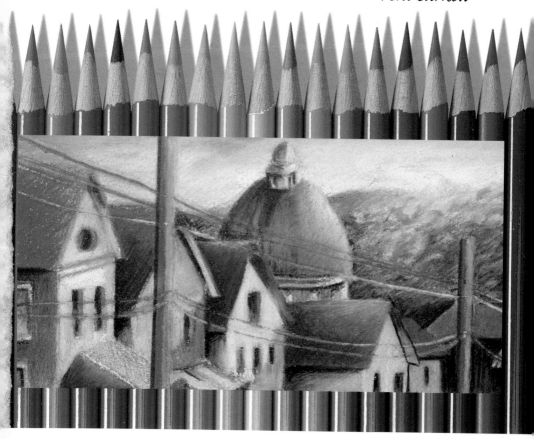

QUARRY BOOKS
Rockport, Massachusetts

First published in the United States of America by:
Quarry Books, an imprint of
Rockport Publishers, Inc.
146 Granite Street
Rockport, Massachusetts 01966-1299
Telephone: (508) 546-9590
Fax: (508) 546-7141

Distributed to the book trade and art trade
in the United States by:
North Light, an imprint of
F & W Publications
1507 Dana Avenue
Cincinnati, Ohio 45207
Telephone: (800) 289-0963

Other Distribution by:
Rockport Publishers
Rockport, Massachusetts 01966-1299

ISBN 1-56496-266-0

10 9 8 7 6 5 4 3 2 1

Designer: Laura Herrmann Design
Cover: A *Small Town* by Vera Curnow
1.5" x 5.5" (3.8 x 14 cm)
Cover Photography: Michael Lafferty

Manufactured in Hong Kong by Excel Printing Company

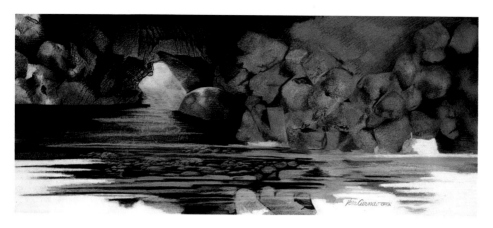

WATER CLOSET #1
Vera Curnow

ACKNOWLEDGMENTS

As the founder of the Colored Pencil Society of America,
I dedicate this book to:

ALL CPSA MEMBERS

*Your excellent work, individual contributions, and active support
have caused a tidal wave of interest and recognition for this once
obscure medium. I no longer feel that I stand alone.*

Thank you.

TABLE OF CONTENTS

DEEP OCTOBER

15 x 10 in (38 x 25 cm)

Vera Curnow

A snow scene does not always have to be blue and white. This landscape, with its abstract quality, is painted with primarily warm colors. Colored pencil and odorless mineral spirits were used to blend and soften the edges.

INTRODUCTION

Vera Curnow

"The aim of art is not to represent the outward appearance of things, but their inner significance."

— *Aristotle*

"If you have seen one tree, you have seen them all!" Okay, I admit it, that was once my attitude toward the great outdoors. Raised as a city girl, Sundays with my family included those dreaded leisurely drives through the country. Five of us—me always in the middle—in a '57 Ford. I was not amused, let alone inspired. While the others *oohed* and *aahed* over the passing terrain and whatever color the season displayed, I read a book, counted barns, and daydreamed. If I could not climb the trees, I felt that looking at them served little purpose.

The same kind of detachment I felt as a kid in the car is obvious to me in many landscape paintings I have seen. Some students approach trees with a fundamental attitude—that is a birch, that one is a maple, that one, a pine— and end up with botanical renderings.

Accurate, yes, but generic. Artists with a commitment to their subject see beyond its physical properties. They do not paint *things*— whether tree, pond, or mountain—as bits and pieces within one frame, they see the impact of the whole.

Learn to capture the feeling of your surroundings. And express that feeling in a unique way—yours! Start by changing your habitual color choices. Paint water or sky without using blue, or a landscape without any green; make lavender snow and violet shadows. Try a new technique. Paint a scene realistically— then paint it again in a contemporary style. Experiment. Make mistakes. But make a statement. In doing landscapes, ask yourself what is it you want to say about this place, this time. Don't just set a stage, set the mood. After all, there is more to a forest than just its trees.

THERE'S A PICTURE OUT THERE

What if I asked you to paint a landscape of Abu Dhabi? An impossible task if you have never seen or heard of Abu Dhabi. Now imagine that I give you a reference photograph of the landscape. That makes things much easier, but still The only thing more daunting than having to paint from your own photographs is having to paint from someone else's. With no personal conviction, no emotional experience or memory of a place—and with nothing to remind you of the scents, sounds, and movement of the day—you must rely on practical knowledge, intuition, and imagination to make the landscape come to life.

Painting landscapes in your studio may not be as challenging as working in that vast theater-in-the-round. However, painting from reference photographs is certainly more practical, productive, and yes, more comfortable than painting *en plein air*—even with the uncomplicated portability of the colored pencil medium. The problems begin when artists strive for realism by depicting a photograph too literally—since the untrained eye does not see all of the distortions produced by the camera. If you unquestioningly duplicate a photograph, your artwork will be stiff and two-dimensional—an obvious reproduction.

In the pages that follow, nine artists (divided into three groups) interpret a landscape from a photograph. Each group was given one of the photographs shown and then asked to imagine that scene stretching before them. Just as they might weed out the mundane and unessential when working outdoors, these artists had to crop the photograph to create a landscape from within the landscape. Only one of the artists had ever visited the area they were asked to paint. To create the landscapes in this book, they relied on their knowledge of spatial relationships, aerial perspective, and creative expression. Compare their results, from realism to impressionism, and their unique individual approaches to creative colored pencil landscapes.

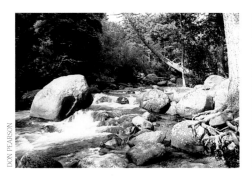

DON PEARSON

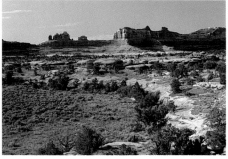

GARY GREENE

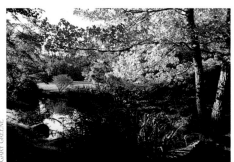

GARY GREENE

Working from a reference photograph confines your vision to a flat, rectangular background. If you use the photograph properly, however, it can also stimulate and help develop your creative and technical resources. How would your version of each of these scenes compare to the versions in this book? (The completion time noted in each section is provided only as a point of interest.)

Please note, pencil colors are listed—as often as possible—in the order in which they were used by the artist. Also, the term painting is used throughout this book. Painting is the process of mixing and blending pigments to create various hues—whether the pigments are colored pencil or paint.

STREAM: Version One

Paula Madawick

"I define my colored pencil work as painterly drawings, which is the best of both worlds."

Painting landscapes from photographs is often a practical necessity. Unfortunately, unless you are a professional photographer, there are bound to be photo inaccuracies of color and proportion that you need to correct. Or not. Paula Madawick applies a literal definition to the term "photorealism"—preferring to document any flaws or distortions the camera records. She even maintains the textural interpretations made by the camera; rendering rocks and trees with the same smooth surface, despite their real-life organic differences.

Paula ignores what she knows about colors "in nature" and reacts to what she sees in the reference photo. In this case, she responds to the overall violet tint of the picture by altering colors and images so that they will "read" logically in an otherwise illogical palette. She is adept at making subtle shifts from warm to cool color temperatures. By staying true to the reference material, Paula produces the interesting image of the landscape photograph, rather than the image of the landscape itself. Misinformation. Optical illusion. Manipulated color. All of these are just additional stimuli for Paula's imagination.

GETTING STARTED

The image was first traced in ink onto tracing paper, then enlarged with a photocopier. The enlargement was transferred to watercolor paper with homemade graphite carbon paper.

COMPLETION TIME

21 Hours

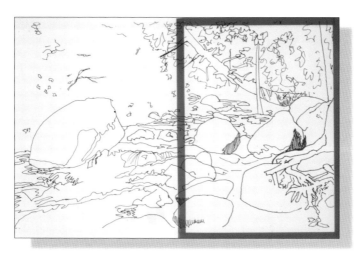

▲ Cropped area used from Reference Photograph.

PALETTE

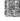 Deep Vermillion

 Rose Pink

 Imperial Purple

 Dark Violet

 Light Violet

 Sky Blue

 Indigo Blue

Turquoise Blue

Jade Green

Water Green

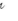 Mineral Green

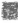 Grass Green

 Burnt Carmine

 Chocolate

 Ivory

 Black

 Gun Metal

Blue Grey

White Light

Cool Grey

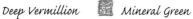 Spring Green

 Royal Blue

 Evergreen

 Light Salmon

 Dark Salmon

 Burnt Sienna

 Light Warm Grey

 Medium Warm Grey

SURFACE

Winsor & Newton
Acid-Free Hot
Press 140lb.
Watercolor Paper

SUPPLIES

Water-soluble
Colored Pencils
Single-edge Razor
Blade
Electric Sharpener
Plastic Eraser
Cosmos Synthetic
16-70 Brushes
#6 and #8
Sanding Block

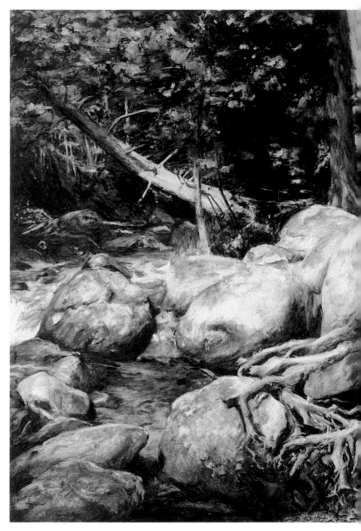

VERA'S VIOLET VISION

9 x 7 in (23 x 18 cm)
Paula Madawick

The entire painting is first
rendered with dry, water-
soluble pencils. When the
dry layers are at nearly the
desired density, a wet brush is used to create fluidity and color saturation. This
changes the drawn image. Once the paper is dry, more layers of dry color are
added. This wet and dry procedure is alternated—defining shapes, darkening
shadows, and removing pigment—until the desired effect is reached.

▶ Pencil strokes, laid with a tonal application, follow the form and movement of the shapes they define. Sharp pencils are essential. Pale pink, green, and blue tints are laid next to their complements in the foreground. The white areas are the surface of the paper.

◀ Water-soluble pencils, applied either damp or wet, diffuse details and create soft or lost edges. To keep certain areas from getting too wet, the artist moistens the pencil by placing it in her mouth. She notes that each pencil has a different taste.

▶ Hard edges appear in the foreground but soften as the landscape recedes. The rocks are burnished with white and light pink. Heavy pressure is used to distinguish the shadows of roots and areas underneath the rocks. Notice the painterly effect visible in this detail.

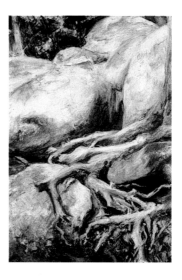

STREAM: Version Two

Don Pearson

"I am a control person so I know anything wet is out of the question. That leaves me with pencils—colored or otherwise. I choose landscapes because they don't have to look like anybody, and I figure if you can't draw a rock, you are in pretty sad shape."

Don Pearson is an admitted "pebble counter": an artist who is motivated by details. As a registered landscape architect, Don deals with form, texture, and color in their more practical applications. As an artist, he uses these same elements to depict landscapes on paper. From the warmth of the sun to the cool of the woods, he meticulously captures the facts, flavor, and feeling of whatever area he paints. His goal is to place the viewer in the middle of the scene—just as it was on the day and at the time he painted it.

This reference photo, taken by Don, serves only to refresh his memory. Extensive editing brings the location into focus. Artistic interpretation conveys its true spirit. And Don's knowledge of the landscape makes it all seem real. He floods the scene with texture, but still manages to project tranquillity. In spite of all the information presented in the picture, there is a sense of order. We can grasp the impact of the whole landscape, or stroll through it one step at a time.

GETTING STARTED

With the help of a slide projector, the artist made a contour drawing with pencils the same colors as the subject. He began the painting in the lower right-hand corner, progressing upward as he completed each section.

COMPLETION TIME

40 Hours

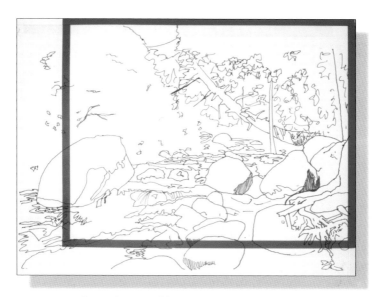

▲ Cropped area used from Reference Photograph.

PALETTE

True Blue

Light Blue

Cloud Blue

Cool Grey 70%

Periwinkle

Sepia

Dark Brown

French Grey

Sienna Brown

Raw Umber

Burnt Ochre

Beige

Light Flesh

Jade Green

Goldenrod

Marine Green

Bronze

Celadon Green

Cream

Limepeel

Chartreuse

SURFACE

Strathmore 500
 Series 2-Ply Bristol
 Regular

SUPPLIES

Wax-based
 Colored Pencils
Artist's Knife
Electric Eraser
Kneaded Eraser
Workable Fixative

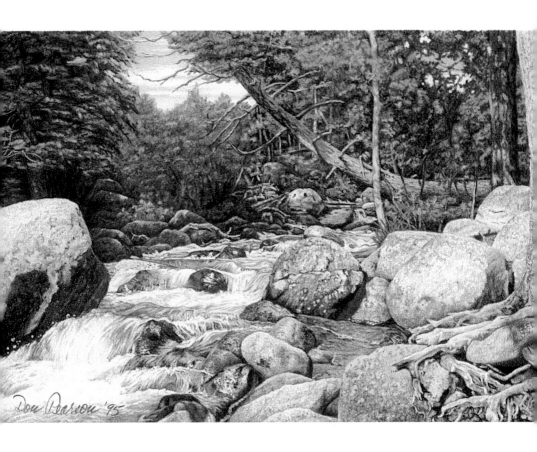

BOULDER BROOK

8 x 12 in (20 x 31 cm)

Don Pearson

By showing only part of the large boulder on the left and part
of the tree on the right, the artist reminds us that this real-life
scene does not end at the edge of the paper. These elements
also focus attention toward the center of the picture.
Notice how the converging shape of the stream leads us
through the scene.

▶ The artist enlarges the sky area to bring more light to the landscape, and adds interest by making the branches from the tree intersect the added expanse of sky and clouds. To create "air openings" in the sky, he uses an electric eraser and eraser shield on the heavy evergreen. Notice the soft edges in the foliage.

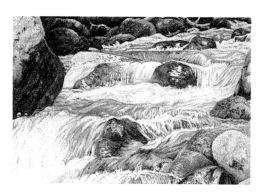

◀ For the rocks, Pearson draws light areas with a loose, circular motion to simulate a flaking, weathered surface. He avoids making linear strokes here, since they would yield a less realistic result. The grain of the paper provides highlights, and also helps make the rocks look real. Hard lines at the edges of the boulders help to define and position them.

▶ Burnishing distinguishes the texture of the water from that of the rocks: Cascading water is burnished with white; still water with light blue.

STREAM: Version Three

Elizabeth Holster

"A beautiful picture attracts attention, but a picture with something to say sustains interest."

Look closely. Common rocks in simple forms? Yes, but . . . Elizabeth Holster offers us an unsettling surprise—one so subtle, so elusive, that upon discovery you still question what you are seeing. For nearly ten years, rocks have been the foundation of Elizabeth's work—but not the subject. While these everyday objects dominate her paintings, Elizabeth's focus is not on their visual description but on their placement. She intentionally manipulates her landscapes into distorted spatial planes and makes them seem plausible.

The scene Elizabeth draws here is actually a composite of two or more photographs that have been selectively cut apart and rearranged as a collage. She renders objects realistically, but then places them in a surrealistic space. Elizabeth blends the two photographs into one painting by unifying colors, values, and shapes. Although the final composition looks very real, there remains with the viewer a nagging feeling that something is not quite right. The perspective is irrational. Look again. This is a scene that could never exist in the real world.

GETTING STARTED

Using the reference photo and a photograph of her own, the artist made color copy enlargements of each in the appropriate scale, cut them, and taped them together. The entire picture was divided into a one-inch grid and then drawn freehand on the paper.

▼ *Artist's Reference Photograph*

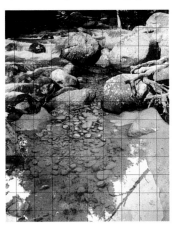

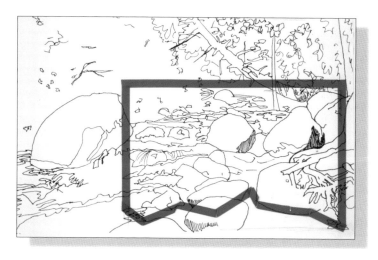

◄ Cropped
area used from
Reference
Photograph.

PALETTE

White

Light Flesh

Dark
Warm Grey

Dark
Cold Grey

Medium
Cold Grey

French Grey

Slate Grey

Light Salmon

Golden Sienna

Sienna Brown

Burnt Ochre

Dark Olive

Burnt Umber

Sepia

Dark Brown

Cloud Blue

Periwinkle

Deco Blue

Ultramarine

Indigo Blue

Blue Violet

Black Grape

Black

SURFACE

Arches Hot Press
 Watercolor Paper

SUPPLIES

Wax-based Colored
 Pencils
Electric Sharpener
Hand-held Sharpener
White Plastic Eraser
Workable Fixative

COMPLETION TIME

100 Hours

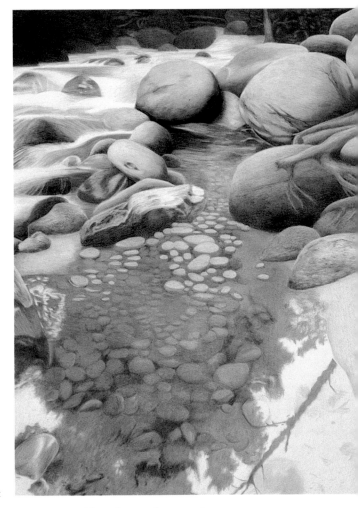

STILL POND

15 x 13 in (38 x 33 cm)
Elizabeth Holster

Making the picture format
vertical eliminates the dark
area on the left and all of
the foliage. In combining
two photographs, the biggest
challenge is to create a convincing transition. Here, the area between the
background waterfalls and the stagnant reflecting pool in the foreground. The
color and temperature differences in the two areas are also obstacles—notice
the coolness of the top versus the warm colors in the bottom.

► *The artist gradually builds layers until the surface is nearly saturated with color. She then burnishes the colors with increasing pressure to completely cover the surface of the paper. The lightest values are ten percent greys—warm in the foreground and cool in the distance.*

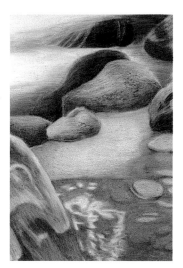

◄ Cream and warm grey colors are used in the light-reflecting areas of the water. The artist avoids being too literal when defining the water.

► *Approaching the middle ground, warm earth tones gradually give way to cooler tones of water and rock. Some of the opposing temperature or color is included in each section for harmony.*

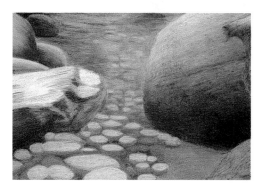

FIELD: Version One

Pat Averill

"It is too tedious to draw every leaf, so I fake them. I also have no idea what is in those shadows—and I don't really care—I just make up something that looks plausible."

The focal point in this reference photograph is screamingly obvious. There is just no way to ignore the bush. The artist has three choices: change its color, crop it out, or—as Pat Averill opted—boldly feature it in the landscape. Pat unabashedly directs us to the subject in every possible way. The pond and its border of reeds serve as a path to the bush. The foreground shadows and surrounding tree leaves, including those overhead, point to it. And the dark background frames its bright color.

Pat omits most of the foreground and the right side of the photograph. She then graphically prunes the barrage of detail that competes for attention. Every area is simplified. The vibrancy of the red bush is subdued by eliminating the overpowering yellow leaves. The strongest sunlight patterns are confined to the grass area. The now uncluttered pond allows the viewer's eye to rest. Pat judiciously metes out the overwhelming abundance of nature in a powerful, yet believable, presentation.

GETTING STARTED

The horizon line and other directional lines were drawn to indicate the basic composition. Once the dark areas were sketched in, the artist used a slide projector to position the large tree and branches. The rest of the landscape was drawn freehand, using the negative shapes as a guide.

COMPLETION TIME

58 Hours

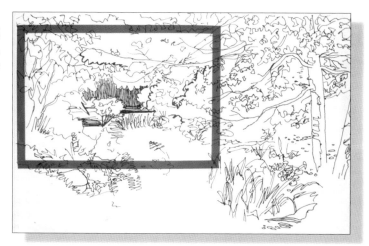

► *Cropped area used from Reference Photograph.*

PALETTE

Turquoise	Apple Green	Yellow Ochre
Dark Green	Burnt Ochre	Chartreuse
Grass Green	True Green	Burnt Ochre
Green Bice	Crimson Lake	Vermillion Red
Zinc Yellow	Crimson Red	Brown Ochre
Scarlet Red	Light Yellow Green	Cedar Green
Tuscan Red	Yellow Chartreuse	Juniper Green
Peacock Green		True Blue
Light Umber	Lemon Yellow	Mulberry
Light Green	Yellow Bice	Terra Cotta
Indian Red		

SURFACE

Arches Aquarelle
Hot Press 140lb.
Watercolor Paper,
White

SUPPLIES

Wax-based Colored
 Pencils
Kneaded Eraser
Electric Eraser
Masking Tape
 (to lift color)
Mat Fixative

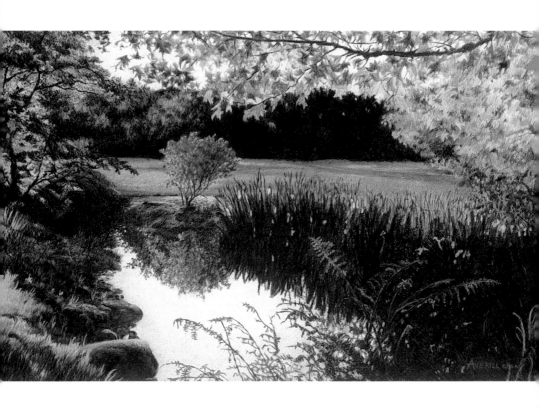

THE RICH LIFE

15 x 26 in (38 x 66 cm)

Pat Averill

What works in a photograph is not always effective in a painting. The reference photo offers more information than the artist needs to capture the mood. Eliminating much of the busy detail emphasizes the serenity of this color-drenched setting. Notice how extending the grassy area creates a calming effect and gives the landscape compositional flow. A variety of soft and hard edges blend the elements, and help avoid that "coloring book" look.

► Green bice and zinc yellow, applied with heavy pressure, define the highlights in the grass. The dark areas are a blend of indigo blue, burnt carmine, and dark green. Spots of color are removed with an electric eraser, to add breathing space and to give interest to the dark shadows. While these light patches resemble cattails, the artist deliberately leaves them vague, for the viewer to define.

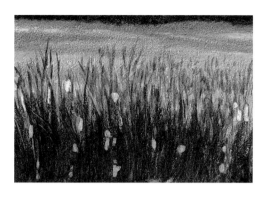

◄ Aside from being a tedious exercise for the artist, rendering the leaves in detail would have given them too much importance. The more detailed an object is, the more it draws attention to itself. Here, leaves are merely implied with short, loose diagonal strokes. Colors are subdued by reducing the areas of red, orange, and yellow, and by framing them with darker shades of green.

► Without some variation in color and value, the dark trees would become a dull, flat mass. A heavily applied blend of Tuscan red, indigo, and dark green helps add volume and texture—but it also creates a slick coat of wax that makes it difficult to add more colors. To lift color, the artist uses a kneaded eraser or masking tape. Light green and red highlights are then applied in the lifted areas.

FIELD: Version Two

Linda Wesner

"Each beginning with a blank piece of paper is another frontier to explore."

As with any subject, when you paint a scene from nature, begin by knowing what you want to say. For Linda Wesner, creating a mood is more important than documenting the scene before her. Her first instinct in examining the reference photo was to look past the shrill fall foliage and pursue a quieter voice. Linda uses color as a means of expression rather than decoration. Muted greens, complemented by rusty browns, transform the brashness of autumn into the solemnness of late summer. She notes that predominantly yellow and orange artwork just does not sell in her area.

Linda chooses the right side of the photograph for her landscape. The tall grasses in the left foreground and the trees to the right, eliminate potential "dead corners" and place viewers on a winding path. Though the path is barely visible in the photo, Linda exaggerates it in the landscape to unify the composition. Its converging perspective leads into the background, while the void of activity on the pond holds viewers' attention. By selectively subtracting, adding, and repositioning information, until only key elements remain, Linda presents a personal viewpoint.

GETTING STARTED

To construct the composition and determine value patterns, three 6" x 4" preliminary sketches were drawn with black marker on typing paper. Linda tests color combinations on sample stock and then uses a two-inch grid to draw the subject on the paper. *(below)*

COMPLETION TIME

10 Hours

▼ *Preliminary Sketches*

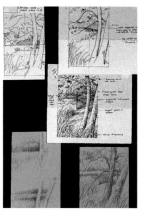

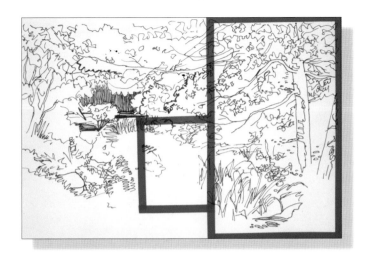

◄ Cropped area used from Reference Photograph.

PALETTE

 Russet

Black

 Light Green

White

 Indigo Blue

 Dark Green

 Moss Green

 Lime Green

Jade Green

 Indian Red

Turquoise Blue

Ochre

Cream

Purple Violet

Salmon

Spring Green

COLORED ART STICKS

Light Green

Dark Green
White

SURFACE

Strathmore 500
 Series, Velvet Grey

SUPPLIES

Wax-based Colored
 Pencils
Colored Art Sticks
Electric Sharpener
Medium Sandpaper
Kneaded Eraser
Workable Fixative

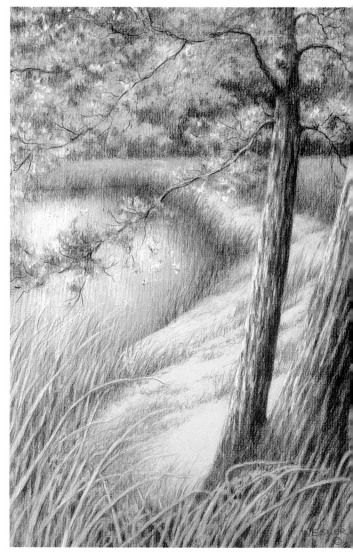

FORGOTTEN PATHS #9

21 x 14 in (53 x 36 cm)
Linda Wesner

A total departure is made
from the original scene.
Besides the color transition,
the biggest impact is in the
reduced range of values. The light source, now subdued by an overcast sky,
eliminates the high contrast between sunny spots and deep shadows. Linda also
ignores the trees and ground cover in the photo, and creates an open field where
there was only dense brush. While this work is derivative of the reference photo,
its source is certainly not obvious.

► Using the "one-third rule", the artist raises the horizon in the picture, then uses vertical strokes to apply a black undercoat for the darkest areas. With increased pressure on the pencil, she adds russet over the black undercoat. Working from dark to light, the last few layers are heavy applications of white art stick. Variations of the same color combinations are used throughout the painting.

◄ To build form and texture, Linda varies the direction of her pencil strokes. Short vertical strokes keep the water smooth— while scumbling creates leaves that have weight and movement. She pays attention to keeping the strokes loose, since their purpose is not to render specific detail, but merely to suggest texture. Notice how the tree branch is positioned to break the open space of the pond.

► The amount of pigment laid on the paper also creates texture and volume. Heavy applications of ten colors produce the thick coarseness of the trunk, thin layers of color depict the grasses, and the plain surface of the paper —kept void of pigment—is used to imply the path.

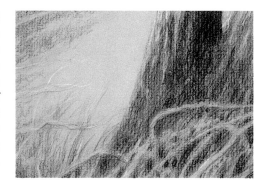

FIELD: Version Three

Eileen Cotter Howell

"I have no qualms about resolving problems directly on the paper. I tell myself that if it doesn't work, I can always start over . . ."

Here is another approach to cropping the reference photo. At first glance, it appears that not much has been omitted. The objects in the slightly cropped perimeter are, for the most part, left intact. A closer look reveals more. Eileen Cotter Howell's interpretation shrinks the whole interior of the landscape. In doing so, she reduces the ambiguous dark areas around the pond to offer a crisp view of the surrounding foliage. The aggressive contrast of shadow and sunlight in the original has now become a delicate balance of values and textures.

Because of the painting's elevated horizon, the activity in the picture—a complicated dance of patterns, textures, and colors—is concentrated in the bottom two-thirds of the piece. Each detail draws the eye upward, toward the bush. And then, nothing. Eileen creates a quiet shrine in the midst of a complex composition. She intentionally avoids placing any "movement" around the focal point. The large masses of subdued color serve only as a backdrop and a quiet place for reflection.

GETTING STARTED

Before drawing the landscape freehand onto the drawing surface, the artist made a graphite study of the scene. (*below*)

COMPLETION TIME

60 Hours

▼ *Graphite Study*

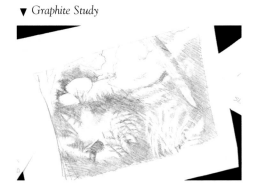

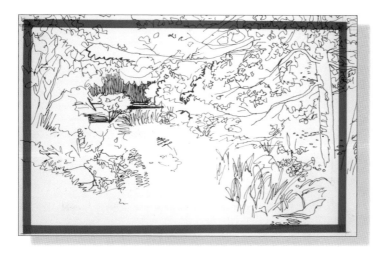

◄ *Cropped area used from Reference Photograph.*

PALETTE

▨	*Indigo Blue*	▨	*Burnt Ochre*
▨	*Violet Blue*	▨	*Yellow Bice*
▨	*True Blue*	▨	*Celadon Green*
▨	*Parma Violet*	▨	*Scarlet Lake*
▨	*Violet*	▨	*Tuscan Red*
▨	*Pink*	▨	*Peach*
▨	*Chartreuse*	▨	*Lemon*
▨	*Dark Green*	▨	*Yellow Ochre*
▨	*Crimson Red*	▨	*Canary Yellow*
▨	*Dark Carmine*	▨	*Orange*
▨	*Olive Green*		*White*
▨	*Black Grape*	▨	*Pale Geranium Lake*
▨	*Dark Purple*		
▨	*Sand*		

SURFACE

Rives BFK 100%
 Cotton, Acid-Free,
 Buffered White
 Drawing Paper

SUPPLIES

Wax-based Colored
 Pencils
Graphite Pencil
Low-Tack Masking
 Film
Electric Sharpener
Handheld Sharpener
Kneaded and Plastic
 Erasers
Workable Fixative

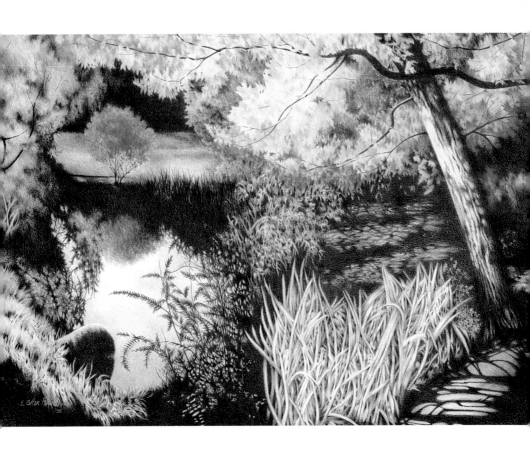

AUTUMN TAPESTRY

22 x 30 in (56 x 76 cm)

Eileen Cotter Howell

Even though many of the shadows have been lightened
or removed, the finished artwork retains the mood of the
original landscape. Notice how the dark areas, above and
below the red bush, serve as a frame. Black colored pencil
was not used in this painting.

▶ *To make the reeds in the foreground clearer, the artist used masking film to lift some of the pigment from the dense shadows. She then applied chartreuse, lemon, and orange highlights in the lifted areas, to complement the violet blue and purple of the dark ferns.*

◀ *Soft edges, dark values, and cool colors make the background foliage recede. In contrast, light values and crisp edges—notice the orange lines—define the grass and bring it forward in the plane of the picture.*

▶ *Complementary colors saturate the dark reflections in the pond. Circular strokes, made with the side of the pencil, add a tonal effect. For the pond, the artist blended the colors of the water with her finger and lightly burnished them with white.*

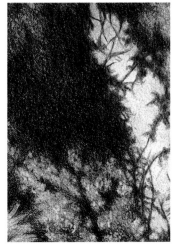

DESERT:
Version One

Barbara Krans Jenkins

*"My drawings have life
in them ... my life!"*

Painting a terrain you know nothing about is like painting a portrait of someone you have never met. The elusive quality that makes a subject come alive is difficult to capture without some firsthand experience. Thus, when Barbara Krans Jenkins, an artist from the green fields of humid Akron, Ohio, agreed to paint this Utah desert from a single photograph, she approached her work with loads of research, a touch of terror, and some spunk.

Barbara began by finding out where the photograph had been taken. Then she did some research, to get enough information to express the spirit of the landscape—rather than merely record its structure. Next, she developed an ecological profile of the desert flora and fauna, and studied the indigenous rock formations. With a little supposition, she was even able to estimate the time of day and the direction of the light in the photograph. Before she felt ready to do the first rough sketches, Barbara did research in 22 books, watched several videotapes, studied a map of the area, and made phone calls to the photographer of the landscape and to a ranger station in Utah.

In the end, although Barbara had never visited a desert, the information she gathered gave her the confidence to accurately portray, and even to personalize, a morning in the Needles District of Canyonlands, Utah.

GETTING STARTED

The artist made value studies and preliminary sketches in pencil and in pen and ink. The final work was drawn freehand.

COMPLETION TIME

48 Hours

▼ *Preliminary Sketches*

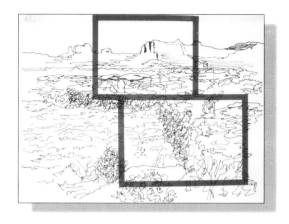

◄ Cropped areas of Reference Photograph.

PALETTE

White

Cream

Beige

Light Cerulean Blue

Copenhagen Blue

True Blue

Mediterranean Blue

Periwinkle

Ultramarine

Violet

Indigo Blue

Jasmine

Sand

Canary Yellow

Goldenrod

Burnt Ochre

Orange

Clay Rose

Henna

Raspberry

Mahogany Red

Tuscan Red

Terra Cotta

Dark Purple

Chartreuse

Peacock Green

Grass Green

Jade Green

Dark Green

French Grey

Sienna Brown

Burnt Umber

SURFACE

Crescent 100% Rag, Hot Press Water-color Board #115

SUPPLIES

Wax-based Colored Pencils
Design Ebony Jet-black Graphite Pencil
Electric Sharpener
Plastic Eraser
Eraser
Koh-I-Noor Rapido-graph 6x0, 13 Pen
Staedtler Marsmagno 4x0 Technical Pen
Pencil Extenders
Metal Stylus
Workable Fixative

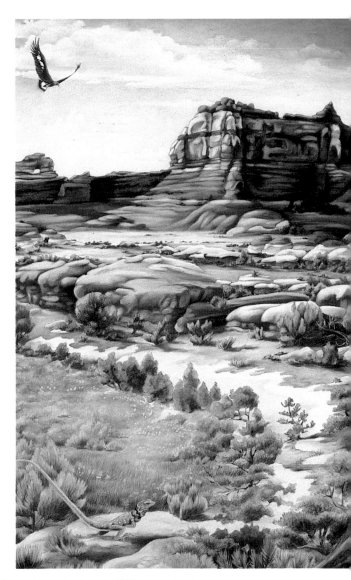

NEEDLES DISTRICT VISTA, CANYONLANDS NATIONAL PARK, UTAH

12 x 8 in (31 x 20 cm)

Barbara Krans Jenkins

This realistic colored pencil rendering reflects the prevailing colors in the reference photo. The vertical format of the work emphasizes the "S" pattern in the picture and draws attention upward, away from the foreground. Clouds add to the overall zigzag white pattern and build the illusion of height and distance. The artist adds wildlife to provide interest and activity.

► Here, the artist builds pigment layers with a tonal application, then burnishes the layers by using a very small, circular motion. The slick, nearly textureless, surface of the paper allowed her to "drag" and blend the concentrated, dry, colored-pencil pigment for a painterly look.

◄ When the artist applies color over the initial pen-and-ink drawing, some lines are covered completely, others remain visible (note the lizard and the grass). Impressed lines, incised with a stylus, define some of the greenery.

► Blended layers of burnt umber, indigo blue, and Tuscan red create the deep shadows in the picture. Further blending with an Ebony jet-black graphite pencil intensifies the colors, smooths the layers, and darkens the values without adding more wax to the surface.

DESERT: Version Two

Teresa McNeil MacLean

"Places are visited more often in thought than in person . . ."

Ahhh . . . Color! Nothing timid, tentative or insipid here. This gutsy palette turns a dusty bowl of brown desert into an electric and juicy expanse of scenery. It is difficult to believe that this artist was once intimidated by color. Teresa McNeil MacLean once viewed color as "an unnecessary complication", and spent many years working only in black and white. Now, she fearlessly slathers on tints, tones, and shades of color to create outlandish landscapes.

Teresa begins by blocking in mass with the prevailing colors of the landscape—beige rocks, green grass, blue sky. The usual. At this early stage, she does not commit to any particular colors, and does nothing that cannot be undone. Colors are applied with a light touch, and then . . . she decides to experiment with purple

The first introduction of a vibrant color cries out for attention, and most artists instinctively try to subdue it. Teresa, however, sees the potential in this bright color as it bounces off the carmine and Tuscan reds. She simply shifts gears on her color wheel and lets the creative process begin. Instead of toning down the high-key color, she intensifies the rest of the palette—phosphorescent orange, neon yellow, liquid aqua. Teresa captures the dancing spirit in each bush, rock, and cloud with conviction and nerve.

GETTING STARTED

The artist drew the scene freehand onto the surface.

COMPLETION TIME

15 Hours

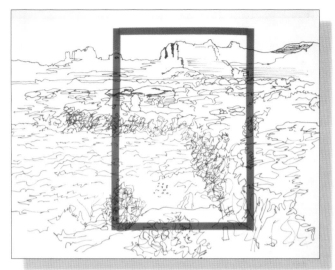

► *Cropped area used from Reference Photograph.*

PALETTE

White	Light Aqua	Indigo Blue
Light Peach	Grass Green	Pink
Cream	Peacock Green	Carmine Red
Beige	Aquamarine	Tuscan Red
Sand	Dark Green	Purple
Lemon Yellow	Cloud Blue	Slate Grey
Light Green	Non-photo Blue	Sienna Brown
Apple Green	Brite Blue Violet	Cool Grey
Olive Green		Black

SURFACE

Strathmore 300 Series Bristol, 100lb. Regular Surface

SUPPLIES

Wax-based Colored Pencils
Design Ebony Graphite Pencil
Hand-held Sharpener
Pink Pencil Eraser
Workable Fixative

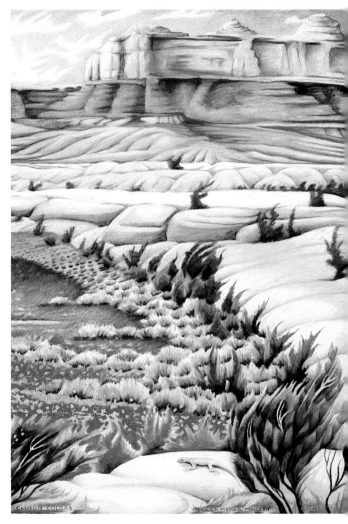

CANYON COLORS

14 x 11 in (36 x 28 cm)
Teresa McNeil MacLean
The high horizon line of this
composition puts the ground
at a "tilt" and restricts the
depth of field. Large, diagonal masses in the foreground break the stratified color
bands in the top half of the picture. This high-key color scheme defines the space
and expresses a personal vision.

▶ Stylized clouds mimic the shapes and patterns of the foliage. To keep edges soft, the artist blends the colors of the clouds into the colors of the sky. To imply atmospheric distance, the colors in this top portion of the picture are muted with white.

◀ The animated shapes of the bushes suggest movement and draw attention upward. A layer of black, burnished with olive green, aqua, and white, colors the bush in the foreground. The layers are gradated, not applied evenly over one another, to expose each color and show value changes.

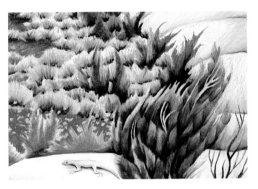

▶ The artist uses heavy pressure to burnish, or, more appropriately, push and drag layers of pigment in the direction desired. At this stage, the concentration of wax pigment virtually rises above the surface of the paper. Be careful—there is a point when a slick surface simply will not accept any more pigment. Here, the final effect resembles a deep lacquered finish over iridescent colors.

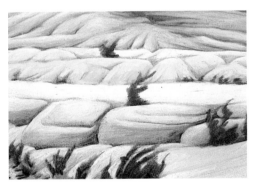

DESERT: Version Three

Mike Pease

"Figuring out which colors to use is made simpler by choosing only three . . . working with a full spectrum of colored pencils seems so cumbersome."

A staccato rhythm of broken color pulsates across the paper. Quick jabs of color, firm and blunt, punctuate each hue. Color next to color. Barely nudging one another at first, and yet, each contributing to the next. No delicate tonal applications. No burnished blends of fused layers. Each stroke retains its identity—somewhat disjointed, but not disoriented. Step back. Your eye is drawn first to the warm masses, then to the cool. Strokes become less discernible as your mind interprets mass. Value patterns take form. Forms begin to recede or advance. You begin to absorb the details within these large shapes—and the landscape leaps toward you. This is impressionism. And Mike Pease does it beautifully.

In art, impressionism involves breaking light into its component parts by observing nature as it really is. That means Mike must approach each scene analytically, to determine how light and color interact. Value is just as important as hue. To add further complexity to this delicate balance, Mike uses only three colors: true blue, canary yellow, and magenta. By varying the mixture of these colors, he can create virtually any hue. This technique may seem like a playful, random application of color, but don't be fooled. Mike Pease works with an abandoned control that requires discipline and practice.

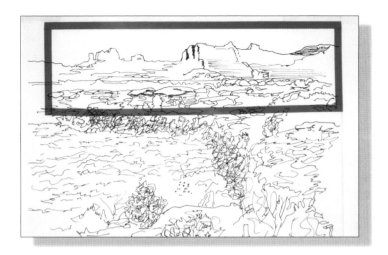

▲ *Cropped area used from Reference Photograph.*

PALETTE

 True Blue

 Canary Yellow

 Magenta

GETTING STARTED

The artist used a slide projector to transfer the scene onto paper, then refined the drawing.

COMPLETION TIME

12 Hours

SURFACE

Crescent 2-Ply
 White Museum
 Board

SUPPLIES

Wax-based Colored
 Pencils
Frisket Paper for
 lifting color
Utility Knife to
 sharpen pencils

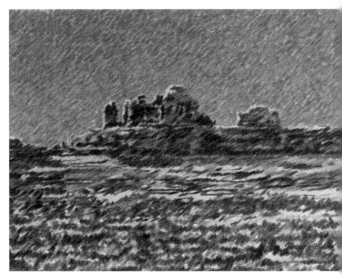

ANCIENT WORLD

10 x 36 in (25 x 91 cm)

Mike Pease

Mike simplified the composition to make it less demanding and to emphasize the power of the rock formations. His approach uses a long, narrow format; omits most of the foreground; limits the detail in the terrain; creates strong value contrasts; and frames the rocks with the background and the foreground.

▶ This detail shows how three process colors create the light and shadow areas of the monolith. In the highlighted area, which is predominately yellow and magenta with some true blue, the artist applied fewer strokes, lighter pressure, and less pigment. The darker side of the landscape, where true blue and magenta predominate, is more saturated, with heavy, thick applications of color.

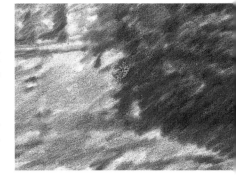

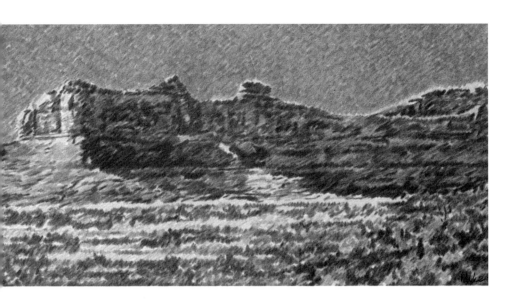

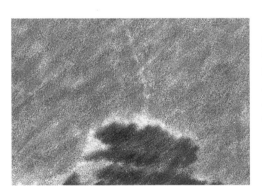

◄ *The dark color of the sky strengthens the (mostly) yellow highlights along the left and top edges of the highest rocks. The sky is mostly true blue, with some added magenta. The artist eliminated the wispy clouds.*

► *Visible strokes, shown here in the foreground grass, are deliberately left disjointed. Take care not to overmix colors when using this technique, it makes them dull, then muddy. Notice the variety of hues that can be created with only three colored pencils.*

A MOVING SCENE

Picture rolling swells of thunderous waves crashing against the rocks: Foam bursts shatter the air, spray and mist are propelled . . .

Stop! Before this frothy mass can hit the beach, let's freeze the moment. The force of this collision and momentum of the thrust are evident. A ton of water has been violently dispersed. And even as it hovers, now stationary, in the vaporous atmosphere, we sense its next movement. It is the anticipation of this next move that artists must capture to make a seascape believable.

Unlike landscapes, which are mostly rooted, cooperative models, water is an ever-changing element. It can be transparent or opaque. It has light, shadows, depth, patterns, and texture. It is reflective and adopts the color characteristics of its surroundings. Water has values, shapes, and forms. And it has movement.

For artists, capturing motion is one of the ultimate challenges. Especially those of us who work with a dry medium such as wax-based colored pencils. When painting with watercolor, water is used to portray water—the fluid motions are just a brush stroke away. Since pencils alone can't produce those spontaneous splashes, sprays, and swirls, colored pencil artists must first draw the action. Our strokes must make the dry pigment flow like liquid, with enough gradations of color, soft and lost edges, and values to avoid that frozen, patterned look. Whether your goal is the roar of oceans of water or the trickle of a dewdrop rivulet, depicting water is a worthy exercise that will enhance all of your paintings.

Waterscapes

WATER FALLS

14 x 8 in (36 x 20 cm)

Vera Curnow

Nothing is more abstract than nature—especially water and sky. Contemporary paintings, such as this one, have few details and keep depth and distance at a two-dimensional level. Colored pencil and solvents work well to capture free-flowing forms. Even if you are using a realistic style to paint a body of water, you should think in terms of abstract shapes to capture its movement.

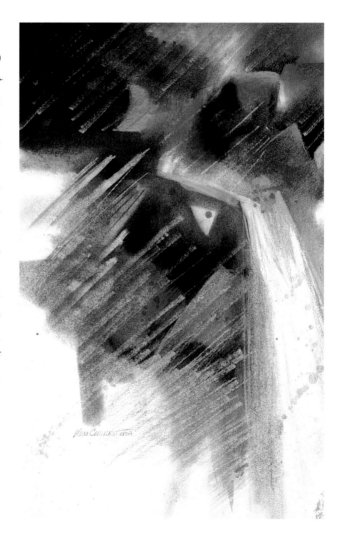

WAVES

Vera Curnow

This seascape just evolved. I normally use *textured* illustration board when I work with odorless mineral spirits (OMS) and wax-based colored pencils. This time, however, I decided to try a very smooth, hot press surface. I discovered that this slick board accepts less color, since there is no "tooth" to scrape the pigment from the pencil. Also, with little texture, the board lacked "valleys" to contain the pigment. The hard surface of the board was less absorbent than paper, too: when I dissolved and spread layers of colored pencil pigment with an OMS-dampened cloth, the pigment sat on top longer. I found myself "chasing" the colors back and forth—building layers of varying color values and temperatures until the natural rhythm of the sea emerged.

GETTING STARTED

This scene was improvised, without a preliminary drawing or reference. Here are some of the items used to drip, splatter, spread, and blend the mixtures of pigment and solvent: a toothbrush, a sandpaper block, a cosmetic sponge, a cotton face-pad, cotton swabs, a poly-foam applicator, a colorless blender, rubber color-shapers, and some craft brushes.

COMPLETION TIME

1 Hour

SURFACE

Crescent Hot Press, Acid-Free Watercolor
 Board #115

SUPPLIES

Wax-based Colored Pencils
Art Sticks
Odorless Mineral Spirits
Electric Sharpener
Electric Eraser
Kneaded Eraser
Pink Pearl Eraser
Plastic Eraser
Cotton Rags
UV-Resistant Fixative

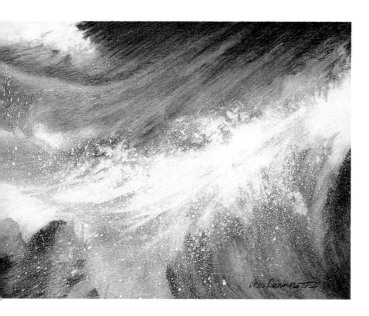

A WAKE

8 x 10 in (20 x 25 cm)

Vera Curnow

This composition takes moving water out of its usual context—without a sky or shore for reference, defining these free-forms is tricky. Notice the fluid movement, choppy areas, agitated swells, and transparent and opaque sections of water. Some dry pencil strokes were added for detail. An electric eraser helped brighten the bursts of white foam.

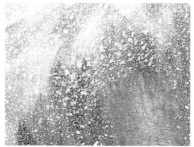

▶ *This detail shows ocean spray and mist close-up. I used a sand-paper block to scrape dry pigment from an art stick, then made the large splatters by flicking a bristle brush, soaked in mineral-spirit and pigment mixture, over the surface. To create the fine mist, I scraped a piece of cardboard across a toothbrush soaked with dissolved pigment.*

PALETTE

 Indigo Blue

 Dark Green

 Olive Green

 Black Grape

 Violet

 Hot Pink

White

 Limepeel

 Yellow Chartreuse

Canary Yellow

 Light Aqua

 Tuscan Red

WATERFALLS

Bruce J. Nelson

SURFACE

2-Ply White Museum Board

SUPPLIES

Wax-based (both soft and hard/thin)
 Colored Pencils
Drafting Tape and Cellophane Tape
Crank-operated Pencil Sharpener
Gum Eraser
Sandpaper
Clear Fixative

T his pointillism technique requires a strong wrist and a hardy drawing surface. Bruce Nelson uses a paper with enough tooth to accept five or six layers of color. With a jack hammer-like motion, Bruce literally pounds the color onto the paper. (He says the tap, tap, tapping used to drive his wife crazy.) As light is absorbed by the dark pigments, and reflected from those that are bright, the dots of color optically blend into three-dimensional objects.

PALETTE

SKY

Light Cerulean Blue

Azure Blue

TREES & FOLIAGE

Yellow Chartreuse

Chartreuse

Green Bice

Grass Green

Dark Green

Black

FLOWERS

Canary Yellow

Madder Carmine

Mulberry

Indigo

Delft Blue

ROCKS

Raw Sienna

Burnt Ochre

Chocolate

Cool Grey 10%

Cool Grey 30%

Cool Grey 90%

GETTING STARTED

The artist used a slide projector and hard grey pencil to transfer the composition onto the drawing surface. He then taped a two-and-one-quarter-inch transparency to the end of an 8x magnifying loupe and referred to it frequently while the work was in progress.

COMPLETION TIME

115 Hours

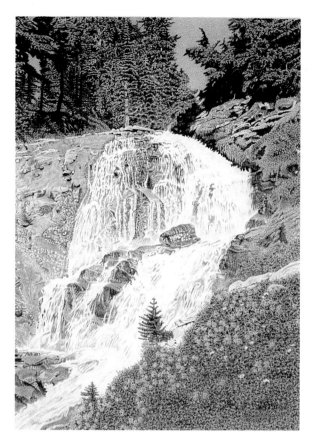

WATERFALL, MT. RAINIER NATIONAL PARK

22 x 16 in (56 x 41 cm)

Bruce J. Nelson

It would be easier and faster to apply the first layers of pencil with a tonal application. However, a solid undercoat would cover any glimpses of white paper. The white showing through the broken colors suggests reflected sunlight, and keeps the colors vibrant.

▶ *The artist covers the entire outline drawing with paper, which he cuts away as the work progresses from left to right. Although he works on the darkest areas of the landscape first, he applies all color in light-to-dark order. In the foreground, the shadows of the trees are black; further away, the shadows are indigo blue to indicate atmospheric distance.*

◀ *Bruce uses sandpaper to keep his pencil points flat. He varies the degree of bluntness, depending on the size of the object he plans to cover. The white of the paper surface, lightly shaded with azure and Delft blue, becomes the cascading falls. Faint linear strokes define moving water, dots of color form the spaces around the water.*

OCEAN

Laura Westlake

L aura Westlake's art shows us that the world does not end at the horizon line. She builds on the illusion of distance, which she creates by drawing clouds in a receding pattern and gradating the colors of the sky to near-white as they approach the water. To contrast with the shallow waters on the shore, she uses dark values to portray distant ocean depths. Laura works with a complementary color palette throughout her painting, blending warm and cool hues on top of one another. By placing light colors first and then gradually adding darker values, she carefully blends layers to create the shimmering, translucent effect of moving water. This dark ocean scene now becomes a sun-filled day at the beach.

GETTING STARTED

The artist used an opaque projector to transfer the photograph of the ocean onto the drawing surface. Clouds and details in the water were drawn freehand.

COMPLETION TIME

35 Hours

SURFACE

100% Rag Strathmore White Bristol
 Vellum 3-Ply

SUPPLIES

Wax-based Colored Pencils
Electric Sharpener
Hand-held Sharpener
Kneaded Rubber Eraser
White Gouache
000 Sable Brush
Pencil Extenders

▼ *Reference Photographs* ▶

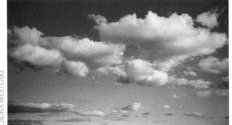

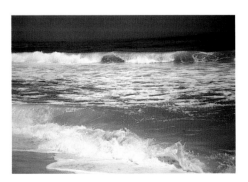

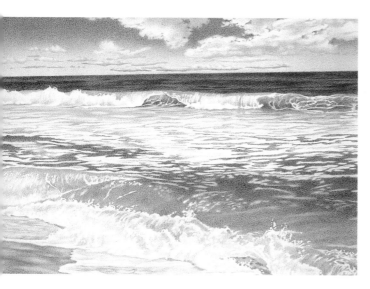

MONTAUK POINT

10 x 14 in (25 x 36 cm)
Laura Westlake

This ocean scene is a wonderful blend of opposites: smoothness and texture; nuance and detail; simple passages and complex patterns; warm and cool colors. Details and sharp colors in the foreground diffuse as they recede into the background. The artist used a white cotton cloth to lightly blend the first layers of pencil.

▶ *Notice how changes in color value and temperature suggest varying depths in the water. Touches of white gouache, over the colored pencil, make veins in the waves and bring out the whiteness of the sea foam. The use of soft- and hard-edges creates movement and keeps the landscape from becoming a patchwork of stiff colors.*

PALETTE

Cloud Blue	Indigo Blue	Cool Grey	Dark Green
Light Cerulean Blue	Jasmine	Yellow Ochre	Sienna Brown
Deco Blue	Greyed Lavender	Light Peach	Dark Brown
Mediterranean Blue	Burnt Ochre	Olive Green	Light Peach
		Jade Green	Deco Yellow

LOOKING UP

*The most influential
element in a landscape is
the sky—even if it isn't
seen in the painting . . .
Think about it.*

This expanse of moving molecules, with its varying degrees of moisture, affects the atmospheric conditions around us. Simply put, the sky controls the characteristics that emit light, create color, provide value contrasts, and dictate depth and distance. Depending on the season and time of day, that astral dome above our heads can turn the world into a dry prism of bright color or a wet wall of cold grey.

As a simple rule, a detail-filled landscape works best with a plain sky. Also, the smaller the sky area, the less detail is required. However, when the sky dominates a large expanse, as with a low horizon, the more it needs to be defined. That doesn't mean you must crowd it with color and movement, but there should be enough gradation in hue to keep it from looking like a flat backdrop.

Because of its all-encompassing influence, don't treat the sky as an afterthought. Decide at the outset what role it will play in your scene. The sky can add colorful ambient light, provide cloud movement and interest, frame the objects before it, quietly serve as a backdrop, or even take center stage as the focal point.

Skyscapes

UPPER PENINSULA SKY

25 x 18 in (64 x 46 cm)

Vera Curnow

There is a fine line between gaudy and distinctive displays. Since neon orange takes center stage here, I subdued my palette throughout the painting. The subject is the sky, so the details of the landscape are kept to a minimum. Notice that reflections on the water are handled differently than shadows. Unlike shadows, reflections do not slant to the side; they fall directly below the object.

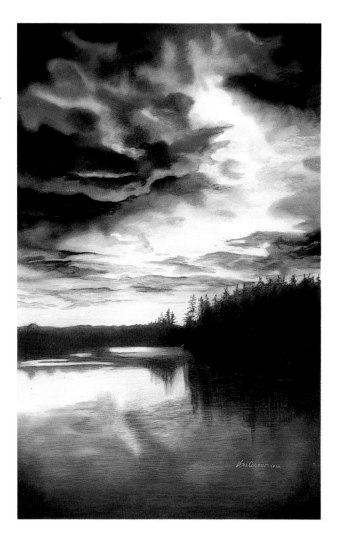

TWILIGHT

Vera Curnow

S pectacular sunrises and sunsets are best left to the photographer. Silhouetted clouds, suspended against colorful explosions of red, goldenrod, fuchsia, and violet, are awe-inspiring in real life—and even read well in photographs. But, their majestic splendor does not always translate well as a subject for painting. We have all seen those saccharin greeting cards with pictures of the sunset. Too easily, sky scenes become garish colors set against a melodramatic backdrop. At worst, they simply don't look believable. Having said all of that, I am drawn to the challenge. My goal is to create a sense of place using a contemporary style. Colored pencils and solvent are excellent for interpreting the free-flowing shapes of the sky.

▼ *Reference Photograph*

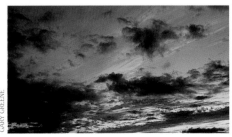

GARY GREENE

GETTING STARTED

I use the photo as a visual reference for the freehand drawing—tracing free forms, such as clouds, makes them look unnatural.

COMPLETION TIME

8 Hours

SURFACE

Crescent Acid-Free White Mat Board

PALETTE

	Deco Yellow		Black Grape
	Yellow Ochre		Black
	Cloud Blue		Peacock Blue
	Periwinkle		Peacock Green
	Lilac		Scarlet Lake
	Hot Pink		Yellowed Orange
	Dark Purple		Sienna Brown
	Process Red		Deco Orange
	Cool Grey 50%		

SKYWARD

13 x 8 in (33 x 20 cm)

Vera Curnow

Even in paintings, clouds do not have edges—color gradations suggest their vaporous nature. This active sky has an abstract quality. Instead of blending layers of color into a single hue, I let individual colors show through. Notice the shafts of light and lines of shadow extending from the clouds to indicate movement.

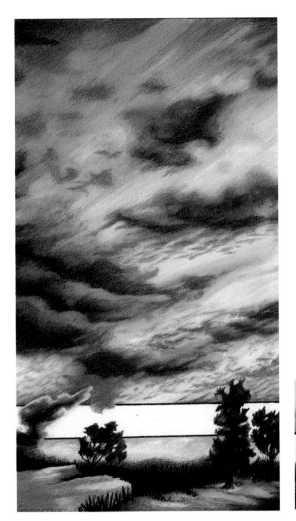

▲ *The land, with its obvious spatial distortions, puts the sky into context. With such a dominant sky, the ground must play a quieter supporting role. The heavy shapes in the landscape anchor and counterbalance the wispy movements of the clouds and sky above. I used a combination technique, which blends the mixture of pigment and solvent with dry pencil strokes and heavy burnishing.*

SUPPLIES

Wax-based Colored Pencils
Odorless Mineral Spirits
Electric Sharpener
Electric Eraser
Kneaded Eraser
Bristle Brush 02
Sandpaper Block
Cotton Pads and Swabs
UV-Resistant Fixative

THUNDERHEADS

Gilbert M. Rocha

Beware of the ten ton cloud. Tightly outlined, uniformly colored, this gravity-defying phenomenon looms solid as a rock in many student skyscapes. Storm clouds in particular, because of their dark colors, are frequently turned from condensed moisture into concrete forms. Gilbert M. Rocha creates thunder clouds with volume—but maintains the translucent quality of these large vapor masses. His clouds have height and bulk; they can obscure the sun, but still show light and shadow. You do not have to be a meteorologist to portray clouds, but understanding their general makeup helps make them believable.

▼ *Reference Photograph*

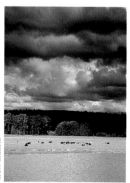

GARY GREENE

GETTING STARTED

The artist used a slide projector to transfer the image to the surface of the paper. He then refined the traced outline, drawing freehand.

COMPLETION TIME

108 Hours

SURFACE

Strathmore 300 Series 2-Ply Bristol Board

PALETTE

SOFT PENCILS

Indigo Blue

Tuscan Red

Violet

Purple

Light Grey

Light Blue

Terra Cotta

Lavender

Peach

Canary Yellow

Orange

Yellow Ochre

HARD/THIN PENCILS

Indigo Blue

Tuscan Red

Violet

Purple

Sea Green

Dark Grey

Peach

Lavender

Light Yellow

Terra Cotta

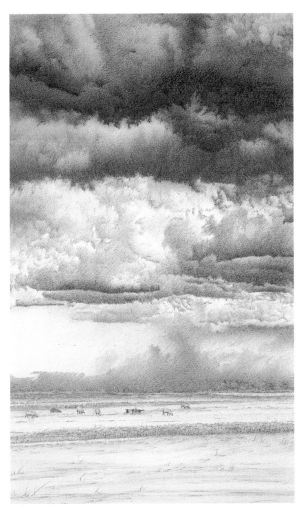

THINGS ARE ABOUT TO CHANGE

14 x 10 in (36 x 25 cm)
Gilbert M. Rocha

The artist changed a green, northern pasture into Nebraskan plains: the lake becomes a stretch of land, trees and hills disappear, Holsteins are replaced, and warm values added. Notice the open space and sense of depth. The atmospheric violet haze at the horizon line creates distance.

▲ *Hatched and cross-hatched strokes define the clouds. The artist used a paper stump to blend the lost soft- and hard-edges that keep the shapes airy and free-flowing. Variations in values create volume and overlapping forms. To suggest the accumulation of moisture, the undersides of storm clouds are dark.*

SUPPLIES

Wax-based (both soft and
 hard/thin) Colored Pencils
Electric Sharpener
Kneaded Eraser
Ink Eraser
Paper Stump
Pencil Extenders
Sandpaper Block
Workable Fixative

CUMULUS CLOUDS

Jane Shibata

Paint what you know. Simple advice that certainly works for Jane Shibata. After 15 years, and an infinite number of variations on the theme, colored-pencil cloud paintings still inspire her. No extravagant color-and-light show, she paints common cloud formations in everyday skies. What makes this work special is the way Jane deftly weaves in and out of reality. With a trompe l'oeil effect, she captures the illusion of three-dimensional space and depth. Knowing that clouds are in constant flux, Jane does not confine them in unyielding shapes: She portrays them with a beautiful sense of freedom and movement.

▼ *Reference Photograph and Sketches* ▶

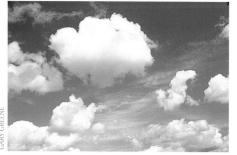

GETTING STARTED

After making preliminary sketches, rough layouts, and color studies, the artist used white pastel crayon to transfer the image to tracing paper. *(below)*

COMPLETION TIME

30 Hours

SURFACE

Strathmore 2-Ply Museum Board, Photo Grey Vellum Finish

SUPPLIES

Wax- and Oil-based Colored Pencils
Blue and White Art Sticks
Kneaded Eraser
White Plastic Eraser
Hand-held Metal Sharpener
Tortillon
Pencil Extender
Workable Fixative

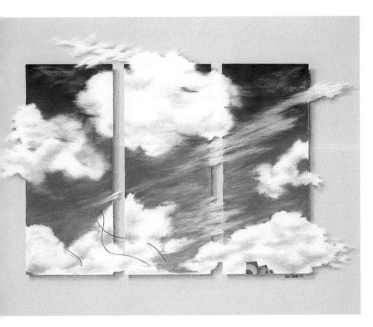

CLOUDY VISIONS

10 x 14 in (25 x 36 cm)

Jane Shibata

The weight distribution in this composition is balanced by giving more volume to the bottom clouds, adding wispy clouds to the upper right, and extending the movement outside the picture plane. Working on a colored surface makes the white clouds and sky stand out; the shadows beneath the panels and clouds create the illusion of three-dimensions.

▶ Because of limited value contrasts, white clouds are tricky to define. The colors of the light shadows must be graduated and burnished to create form and volume. Soft, blended edges keep the clouds transparent. The kites not only lend a dash of color, but position the unseen horizon and subtly imply height.

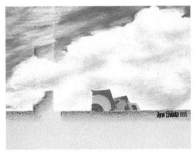

PALETTE

SKY

 True Blue

 Oriental Blue

 Prussian Blue

 Periwinkle

 Mediterranean Blue

 Blue Slate

 Indigo Blue

CLOUDS

White

 Periwinkle

 Cool Grey 20%

 Cool Grey 50%

 Cool Grey 90%

 Cloud Blue

BLOCKING YOUR VIEW

Rural roads or urban streets—regardless of the terrain, the basic principles for rendering landscapes apply. While nature's organic shapes dominate the countryside, the city is a man-made maze of architectural forms. Yet, each scene shares similar characteristics and requires that the artist use the same rules to define the view.

Look at trees, rocks, and mountains. The geometric qualities of urban architecture are also found in these natural formations. Whether you are painting a meadow or a plaza, form and volume are still created with lines and values. The same linear perspective needed to define a picture plane applies to a desert or a boulevard. And aerial perspective creates the illusion of distance, whether for buildings or mountains, through the use of color and value.

While a cornfield has one light source, a city has many. Whatever the light source—direct or reflected, natural or man-made—it doesn't matter. The sun and the moon behave the same in town as they do out of town. And whether it is fog or smog, blue air or yellow, the same techniques apply in adjusting the visibility over a marsh as they do over Cleveland.

If you have always travelled at the languid pace of rural roads, try expressing the frantic energy of urban streets. At the very least, this creative trip to uncharted terrain will help you develop a change of artistic viewpoint.

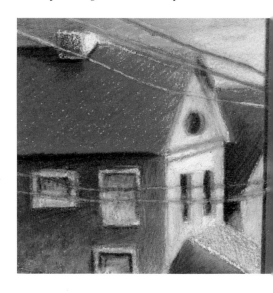

Cityscapes

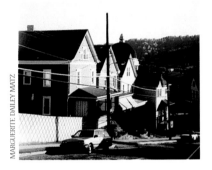

MARGUERITE DAILEY MATZ

A SMALL TOWN

1.5 x 5.5 in (3.8 x 14 cm)

Vera Curnow

Pedestrian views of city streets can be made more interesting by using energetic colors and some creative cropping. A surprising number of colors were used to create this miniature painting.

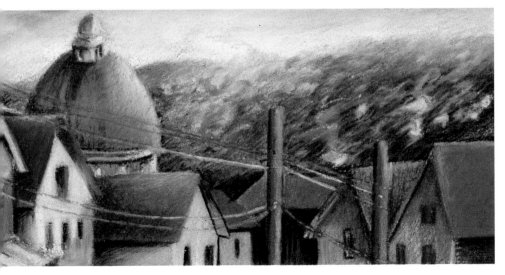

NIGHT SCENE

Vera Curnow

Cities are so linear that many students use a ruler to draw all the geometric forms. This draftsman-like approach creates hard-edged outlines that confine the viewer's attention and make the scene look static. Perfect for a formal architectural rendering, but not so good for fine art. Evidence of the artist's hand makes for a far more interesting painting than do perfectly drafted lines—especially in a night scene such as this, with all its free-flowing refractions of light. This urban scene is a wonderful construction of abstract shapes, compositional weight, color harmony, and distribution. Forms emerge from the untouched areas of the paper, making the viewer see what is not really there.

▼ *Reference Photograph*

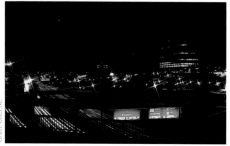

GARY GREENE

GETTING STARTED

The artist used a slide projector and white pencil to help position the composition. The final drawing was done freehand.

COMPLETION TIME

3 Hours

SURFACE

Letraset Black Cover Stock

SUPPLIES

Wax-based Colored Pencils
Electric Eraser

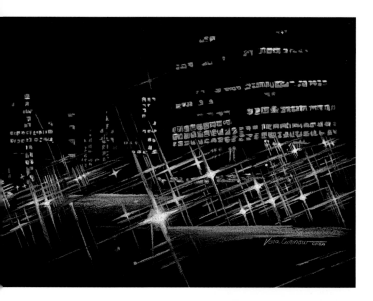

A NIGHT TIME CROSS TO BEAR

9 x 12 in (23 x 31 cm)
Vera Curnow

The condensed composition eliminates the freeway below. Buildings were added to fill large voids in the background. City lights are exaggerated in size and color to balance the design elements of the painting. Two horizontal color bars in the foreground anchor the cityscape. The surface of the paper is an important element in this intricate three-dimensional illusion.

▶ *Abstract shapes and lines are used to create city lights and add movement. Notice how the lighted windows of the building are not solid rectangles of color—irregular shapes and varied colors suggest shadows and reflections from interior objects.*

PALETTE

 Poppy Red

 Aquamarine

 Ultramarine

 French Grey 10%

 Neon Green

 Green Bice

 Grass Green

 Light Aqua

 Lavender

 Lemon Yellow

 Neon Yellow

 Neon Orange

 Orange

White

AERIAL VIEW

Marguerite Dailey Matz

"To begin is the thing . . ."

No matter how daunting the composition or size, each of Marguerite Dailey Matz's paintings starts with a single stroke—even if the subject is an expansive aerial view of downtown Pittsburgh. Marguerite finds the center of the photograph and determines where it would be located on her drawing paper. And then she begins. Drawing the center building first, she uses it as a guide to work outward—one building at a time, each in relationship to another, until the preliminary drawing is complete. When applying colors, however, Marguerite fights the tendency to finish individual areas completely. She carefully balances value relationships over the entire composition, to make this panoramic view function as a whole.

GETTING STARTED

Color swatches, a color photocopy, and magazines served as references. The artist transferred the freehand drawing onto the final surface by using a sunlit window to trace one from the other.

COMPLETION TIME

80 Hours

SURFACE

Rising Stonehenge Pearl Grey, Deckle-edge, Medium Texture Paper

SUPPLIES

Wax-based Colored Pencils
Oil-based Colored Pencils
Art Sticks
Masking Film
Electric Sharpener
Plastic Eraser
Pencil Eraser
Turpentine
Colorless Blender
Matte Fixative

▼ *Artist's References*

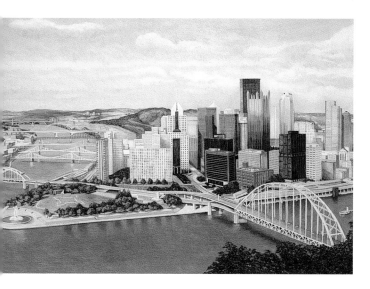

PITTSBURGH PANORAMA

18 x 27 in (46 x 69 cm)
Marguerite Dailey Matz

The large sky and river areas were drawn with art sticks. The artist used turpentine to blend colors in the river, and used a colorless blender for several of the buildings. The paper texture is retained in the sky to contrast with other smooth areas.

▶ *A combination of warm and cool greys color shadows and buildings, and modify atmospheric distance. Heavy burnishing creates smooth surfaces. Though tedious to draw, the tiny windows are necessary details. Notice how naturally drawn lines soften the rigidity of the structures and show the imprint of the artist.*

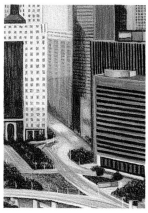

An additional 25 tints and shades were used along with the palette shown below.

PALETTE

Cobalt Blue	Celadon Green	Vandyke Brown	Burnt Carmine
Blue Violet	Jade Green	Golden Brown	Clay Rose
Sky Blue	Mineral Green	Yellow Ochre	Greyed Lavender
Periwinkle	Hooker's Green	Raw Umber	Bronze
Indigo	Juniper Green	Chocolate	Grey
Grape	Cedar Green	Venetian Red	Chinese White

SKYLINE

Merren Frichtl

Merren Frichtl prefers to custom-build the texture of the paper to suit her subject. Using a foam brush, she applies a smooth coat of gesso to both sides of a 4-ply museum mat board to prevent warping. A second coat of gesso is worked on the front with a large, rough house-painter's brush in either horizontal, wavy, spiral, speckled, random or, in this case, vertical strokes. The gesso dries in slight relief. Merren then draws the composition very lightly and applies an undercoat of watercolor to the surface. Since the surface of the board is less porous than paper, the paint sits on top. Once the watercolor is dry, the colored pencil work begins.

GETTING STARTED

Drawn freehand on gessoed mat board.

COMPLETION TIME

18 Hours

SURFACE

100% Rag Museum Mat Board

SUPPLIES

Wax-based Soft and Hard Colored Pencils
Art Sticks Watercolors and White Gesso
Electric Sharpener
Kneaded Eraser
X-acto Knife to scratch in detail
Large House-Painter's Brush
Foam Brush and Stencil brush
Matte Fixative

PALETTE

HARD/THIN PENCILS

- Canary Yellow
- Orange
- Pink
- Purple
- Tuscan Red
- Indigo Blue
- Rose

- Violet Blue
- Non-photo Blue
- True Blue
- Tuscan Red
- Indigo Blue
- Poppy Red
- Black Grape

WATERCOLORS

- Cadmium Lemon
- New Gamboge
- Permanent Rose
- Manganese Blue
- Ultramarine Blue
- Windsor Violet

SOFT PENCILS

- Pink
- Parma Violet
- Raspberry
- Neon Red
- Neon Orange
- Purple

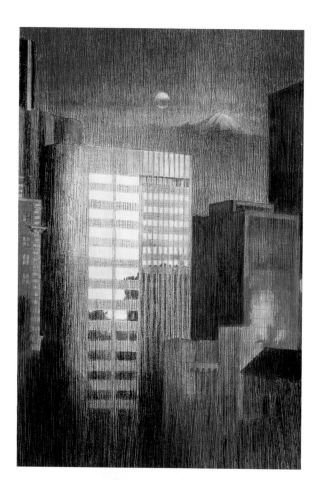

SEATTLE SUNRISE

15 x 12 in (38 x 31 cm)

Merren Frichtl

Colored pencils create rich, complex hues over the painted gesso and are used both to heighten intensity (with analogous colors) and to dull it (with complementary shades). Pencils need to be sharp to work into the textured gesso.

▲ *These details show the fine brushstrokes in the gessoed surface. This technique is fairly forgiving. The entire sky was reworked by removing the wax pigment with a kneaded eraser, washing off the watercolors, and then re-painting with gesso. Gesso can also be applied directly over finished areas to add more detail.*

GALLERY

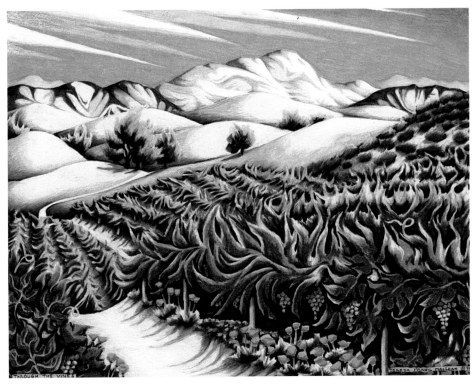

TERESA MCNEIL MACLEAN
Through the Vines
11 x 14 in (28 x 36 cm)
Bristol Board, Regular Texture

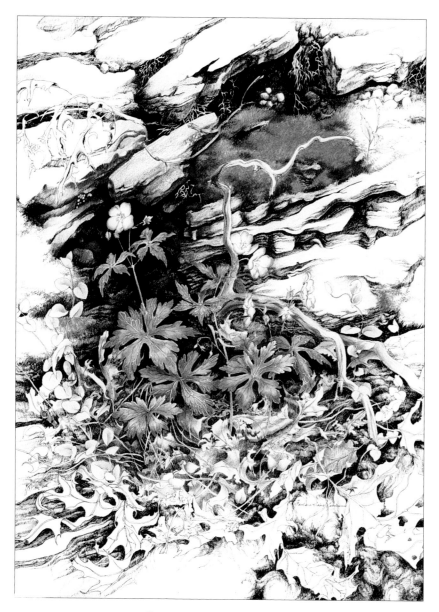

BARBARA KRANS JENKINS

Wild Geraniums

24 x 20 in (61 x 51 cm)

Crescent Watercolor Board #115

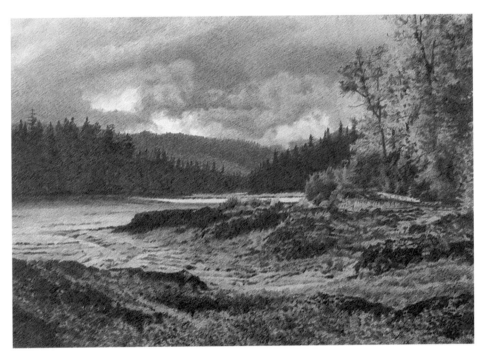

MIKE PEASE

Santiam October

24 x 36 in (61 x 91 cm)

Crescent 2-Ply Museum Board, White

MERREN FRICHTL
Kensington Station – Dawn
12 x 20 in (31 x 51 cm)
Gessoed Mat Board

EILEEN COTTER HOWELL
December Light
29 x 36 in (74 x 91 cm)
Watercolor Paper

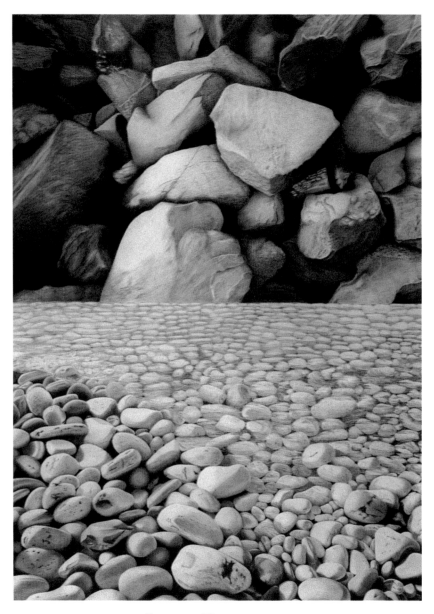

ELIZABETH HOLSTER

Between a Rock . . .

25 x 18 in (64 x 46 cm)

Hot Press Watercolor Paper

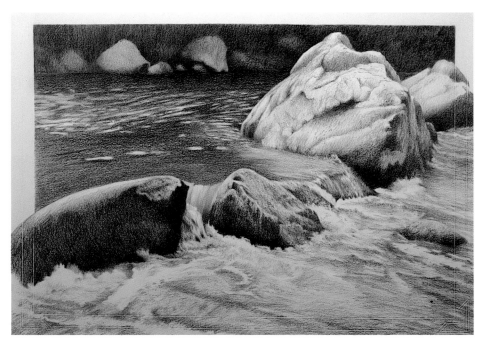

LINDA WESNER

Memory Etch I

13 x 20 in (33 x 51 cm)

Strathmore Rag Illustration Board, White

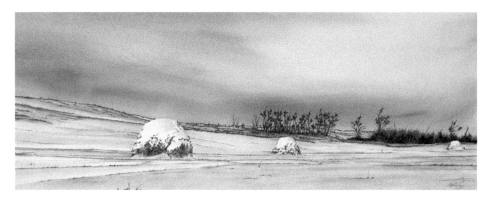

GILBERT M. ROCHA
Rural Rt., North Platte
9 x 23 in (23 x 58 cm)
140 lb. Cold Press Fabriano Watercolor Paper

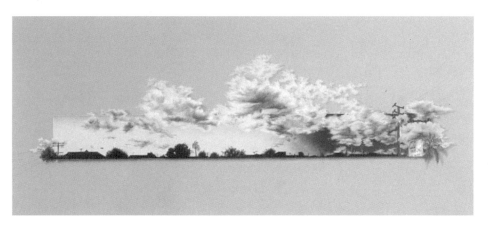

JANE SHIBATA
No Parking in L.A.
16 x 32 in (41 x 81 cm)
Strathmore Museum Board

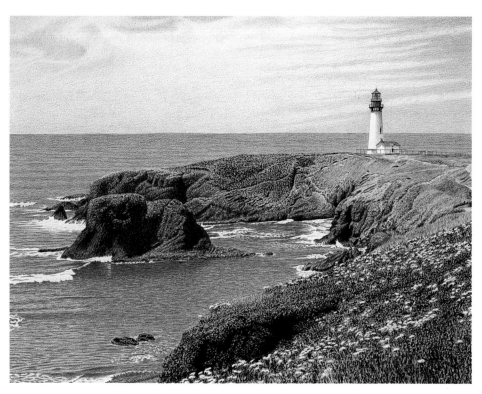

BRUCE J. NELSON

Yaquina Head #2

18 x 24 in (46 x 61 cm)

Strathmore Bristol, 5-Ply Medium Texture

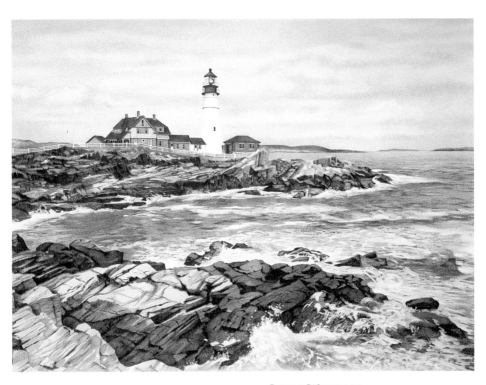

LAURA WESTLAKE

Portland Headlight

16 x 22 in (41 x 56 cm)

Strathmore Bristol Vellum

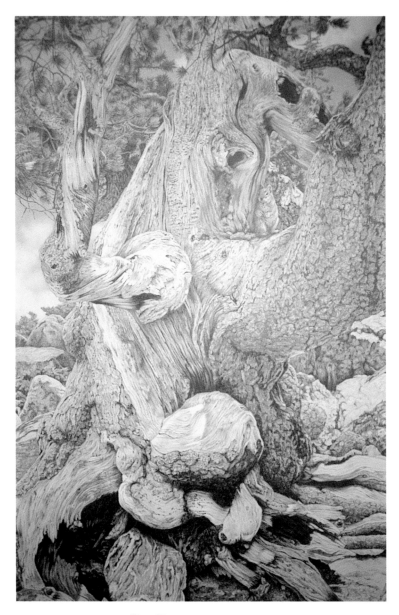

DON PEARSON

Limber Pine

13 x 19 in (33 x 48 cm)

Acid-Free Mat Board

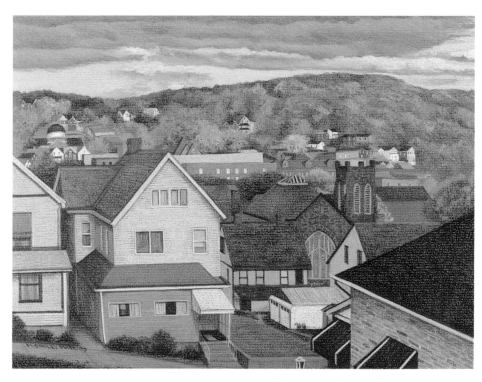

MARGUERITE DAILEY MATZ

From My Parents' Back Porch

16 x 20 in (41x52 cm)

Strathmore Charcoal Paper

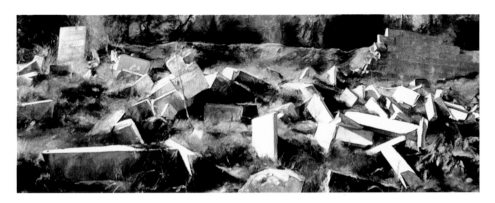

PAULA MADAWICK
East of 9 West, Autumn
36 x 96 in (91 x 244 cm)
140 lb. Hot Press Arches Watercolor Paper Roll

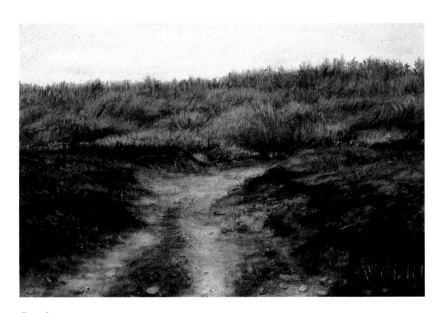

PAT AVERILL
Phantom Path
3 x 4 in (8 x 10 cm)
100% Rag Museum Board

DIRECTORY

Of Artists

ELIZABETH HOLSTER

727 East A Street
Iron Mountain, MI 49801
906 779-2592

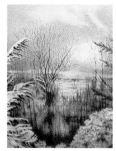

EILEEN COTTER HOWELL

3040 Timothy Drive NW
Salem, OR 97304
503 362-5386

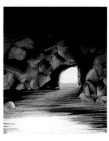

PAT AVERILL

640 Ninth Street
Lake Oswego, OR 97034-2221
503 635-4930

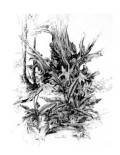

BARBARA KRANS JENKINS

580 Megglen Avenue
Akron, OH 44303-2414
216 836-5850

VERA CURNOW, CPSA

The Electric Pencil Co.
1620 Melrose #301
Seattle, WA 98122-2056
206 622-8661 Phone
206 622-2228 Fax

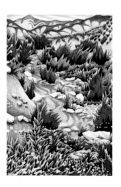

TERESA McNEIL MacLEAN

P.O. Box 1091
Santa Ynez, CA 9340
805 688-8781

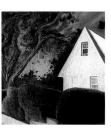

MERREN FRICHTL

Merren Frichtl Art Studio
3766 Howard Avenue
Suite 101
Kensington, MD 20895
301 949-4166

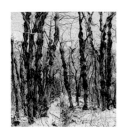

PAULA MADAWICK, CPSA

159 Piermont Avenue
Piermont, NY 10968
914 359 2597

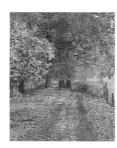

MIKE PEASE

3290 Inspiration Point Drive
Eugene, OR 97405
503 345-8819

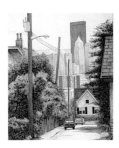

MARGUERITE DAILEY MATZ

207 Alden Road
Carnegie, PA 15106
412 276-0806

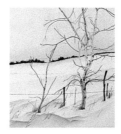

GILBERT M. ROCHA

153 Hillcrest Drive
North Platte, NE 69101
308 534-4623

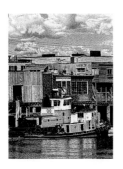

BRUCE J. NELSON

461 Avery Road East
Chehalis, WA 98532-8427
360 262-9223

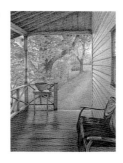

JANE SHIBATA

2024 Purdue Avenue
Los Angeles, CA 90025
310 477-1817

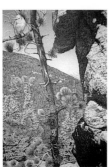

DON PEARSON

7819 South College Place
Tulsa, OK 74136
918 492-8008

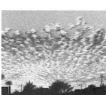

LINDA WESNER

123 Springtree Court
Westerville, OH 43081
614 891-5372

LAURA WESTLAKE

129 Weaver Road
West Sayville, NY 11796
516 567-6832